Fun Days
in Pittsburgh

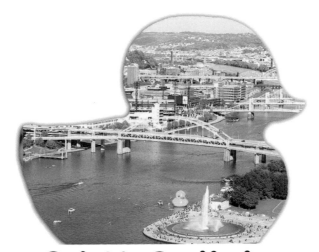

Pat McGrath Avery
&
Joyce Faulkner

LUKE

ISBN: 978-1-93795857-2 (soft cover)
Library of Congress Control Number: 2014902249

Red Engine Press
Bridgeville, PA
Printed in the United States

Thank you to Connie George at VisitPittsburgh.com for her advice and to the destinations we visited.

The rubber duck came to Pittsburgh through the efforts of the Pittsburgh Cultural Trust (www.trustarts.org). Created by Dutch artist, Florentijn Hofman, the duck made its first visit to America in the fall of 2013.

Note to parents: The destinations and services in this book are only a sampling of the activities available in the Pittsburgh area. Kids can enjoy many free outdoor parks as well as the many museums and adventures mentioned in this book. Outdoor activities vary with the seasons.

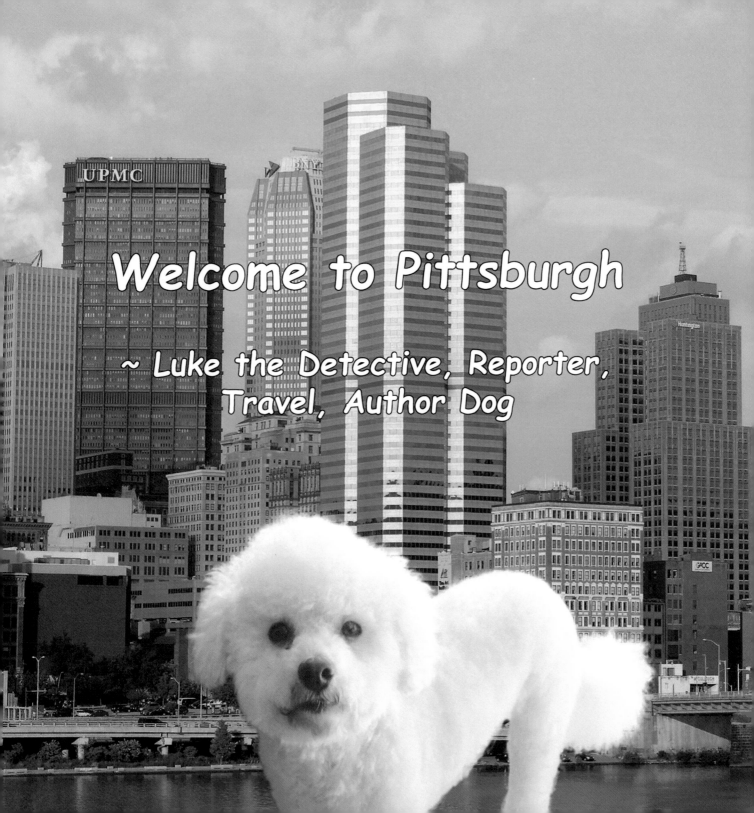

Welcome to Pittsburgh

~ Luke the Detective, Reporter, Travel, Author Dog

Downtown Pittsburgh

Hi, I'm Luke. I visited Pittsburgh at the same time as the giant rubber ducky. Everybody came out to see him. I think he had lots of fun. I hope you visit some of the places in this book like the many bridges and the big statue of Mr. Rogers. I know you will have as much fun as the duck and I did.

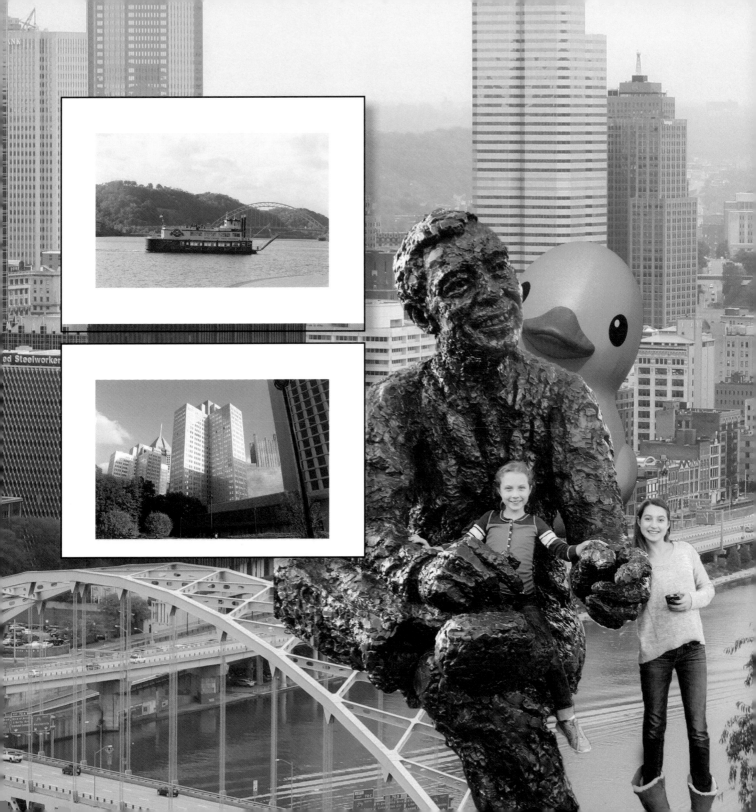

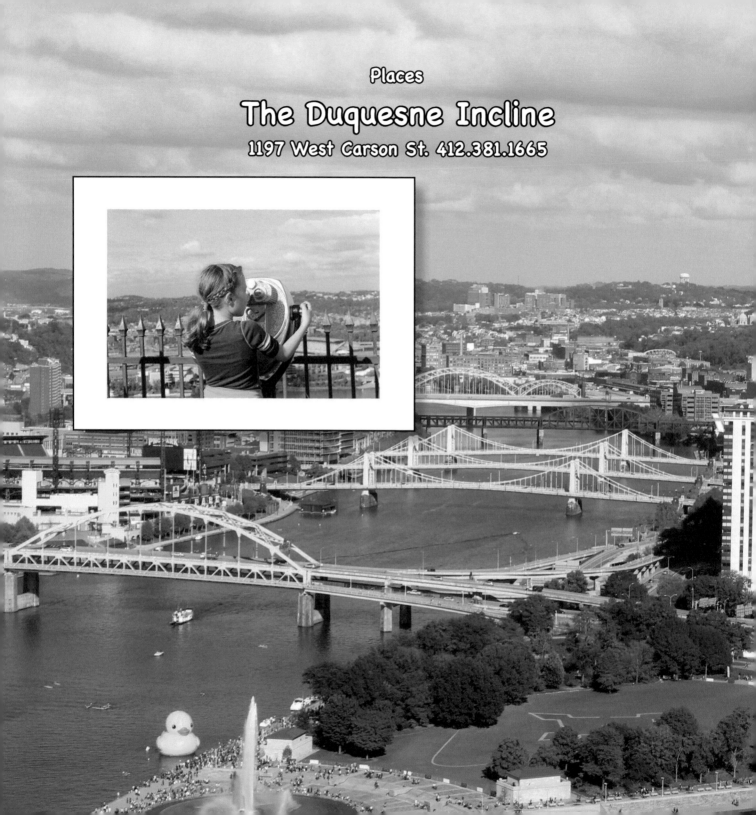

The Duquesne Incline

1197 West Carson St. 412.381.1665

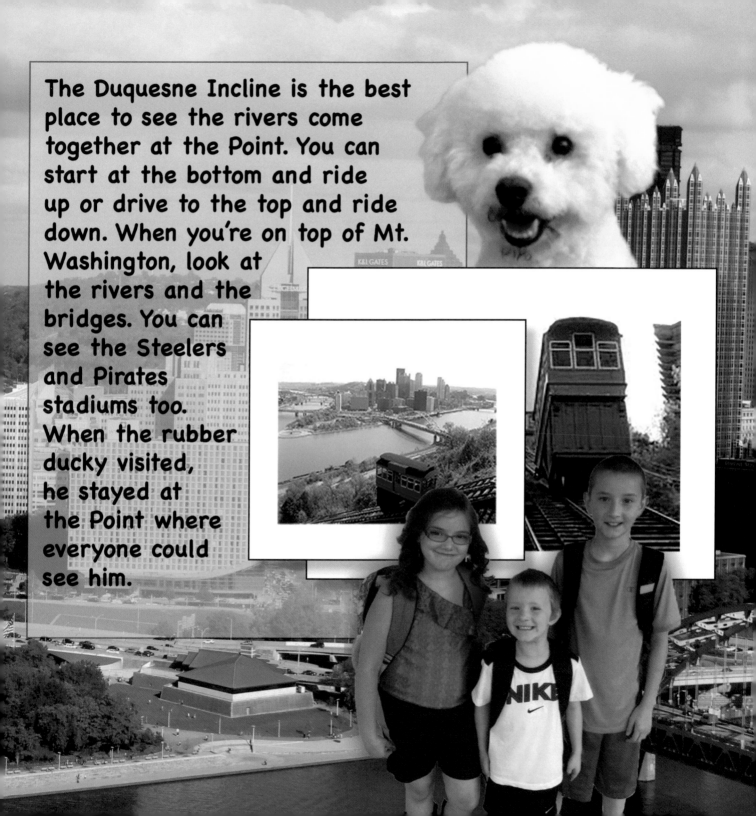

The Duquesne Incline is the best place to see the rivers come together at the Point. You can start at the bottom and ride up or drive to the top and ride down. When you're on top of Mt. Washington, look at the rivers and the bridges. You can see the Steelers and Pirates stadiums too. When the rubber ducky visited, he stayed at the Point where everyone could see him.

Places

National Aviary

700 Arch St. Pittsburgh, PA 15212 (412) 323-7235

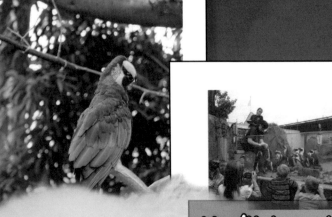

You'll love the birds at the National Aviary. Did you know that 'aviary' means a place for birds? Be sure to see the Penguin and Lorie feedings. You can visit the rainforest and wetlands too.

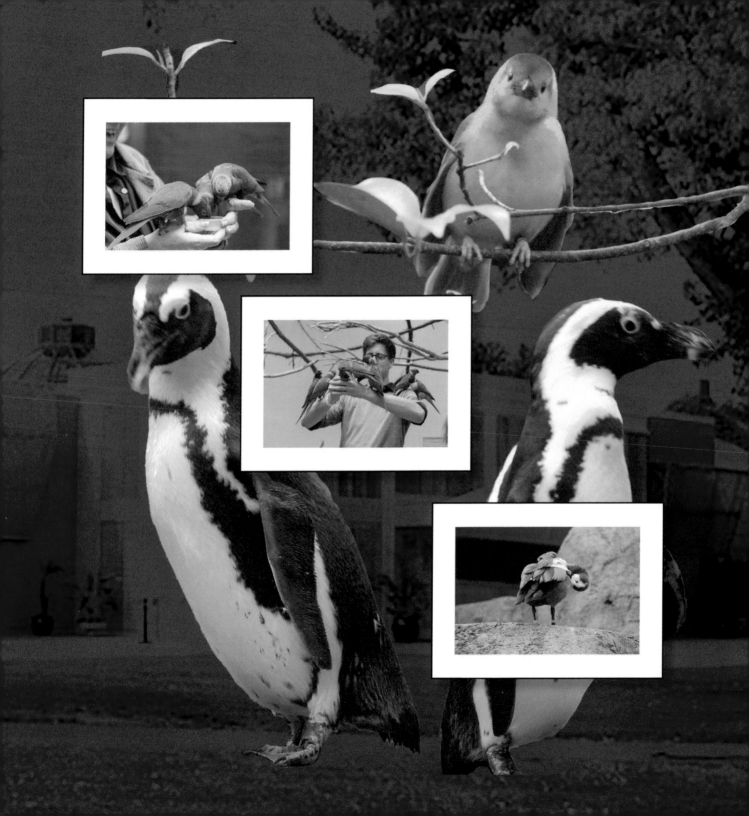

Places
Heinz History Center
1212 Smallman St. Pittsburgh, PA 15222 (412) 622-3131

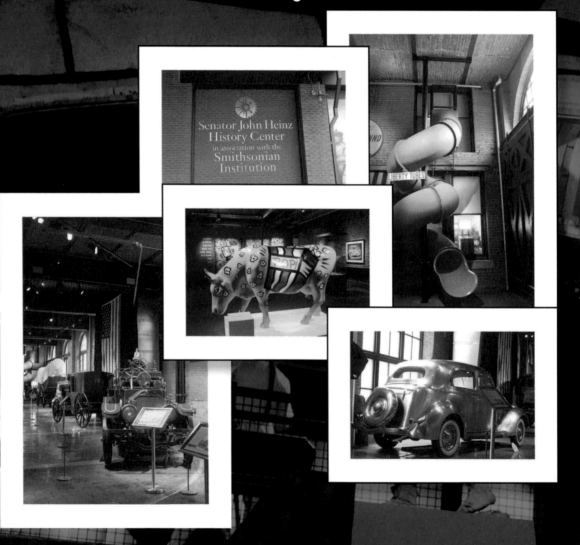

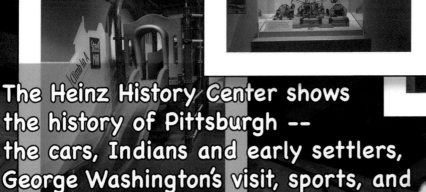

The Heinz History Center shows
the history of Pittsburgh --
the cars, Indians and early settlers,
George Washington's visit, sports, and
much more.

Do you use Heinz Ketchup at home?
This is the home of HJ Heinz who
gave Americans many of their favorite
condiments.

The Ferris wheel, Big Mac, banana
split and Ice Capades all started
in Pittsburgh. It is home to
the first movie theater,
radio station, and World

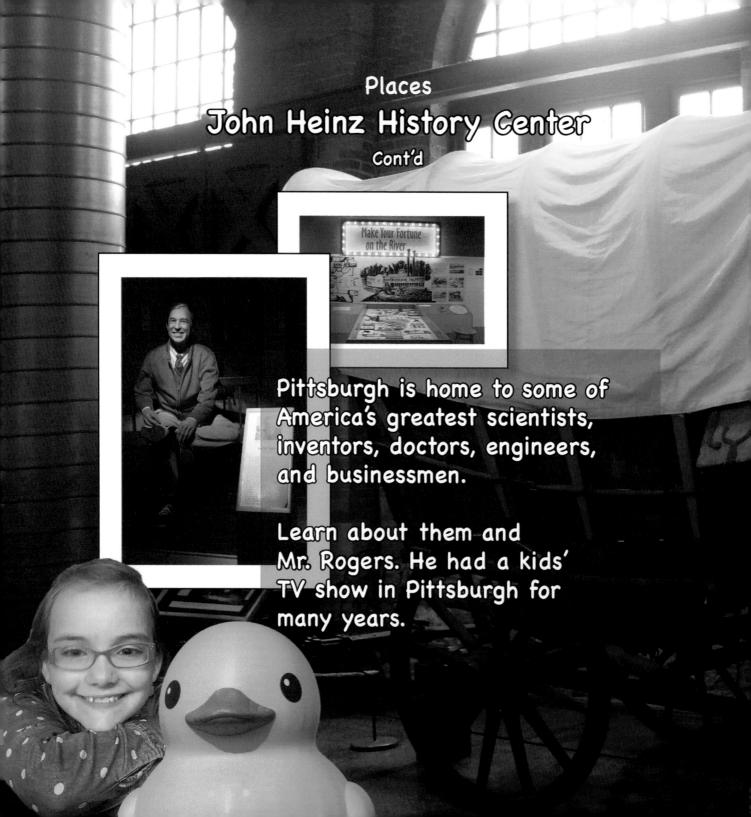

Pittsburgh is home to some of America's greatest scientists, inventors, doctors, engineers, and businessmen.

Learn about them and Mr. Rogers. He had a kids' TV show in Pittsburgh for many years.

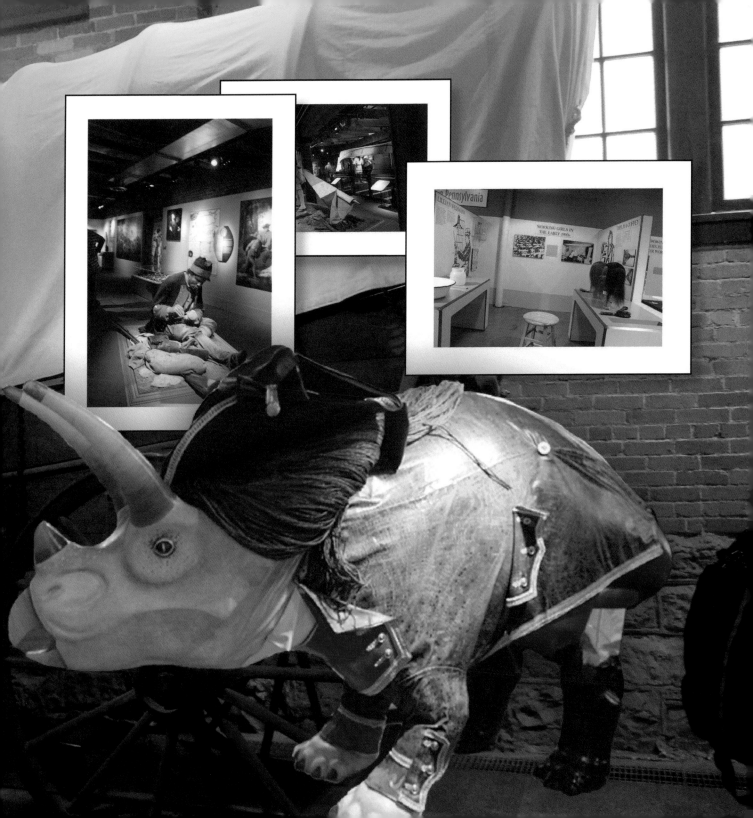

Carnegie Science & Technology Center

1 Allegheny Ave. Pittsburgh, PA 15212 (412) 237-3400

You'll love the Carnegie Science Center. The first display shows all kinds of bikes -- even the kinds your parents and grandparents rode.

Want to learn about space, robots, trains, the stars, or fish? You can even visit a submarine. Be sure to watch a show in the planetarium. Discover the stars, constellations, and planets.

Where Science Happens!

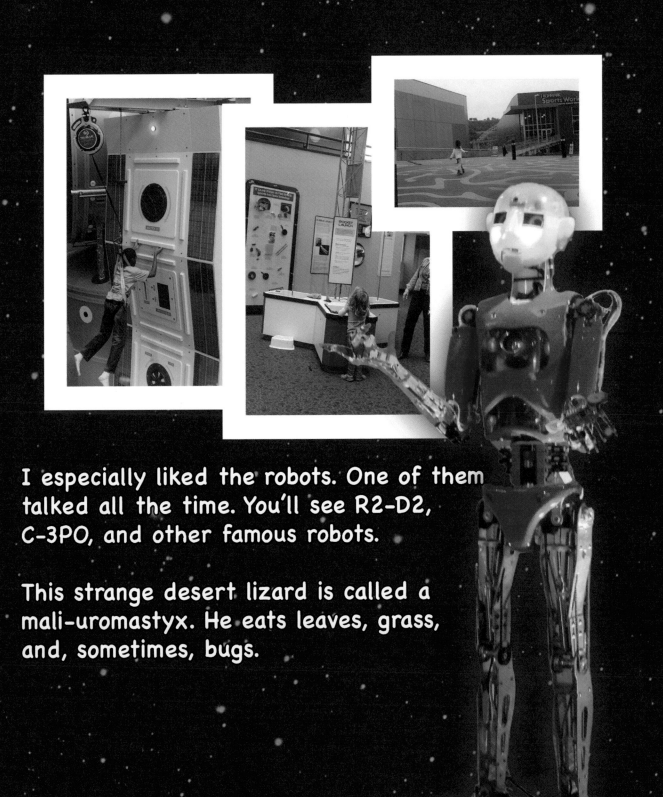

I especially liked the robots. One of them talked all the time. You'll see R2-D2, C-3PO, and other famous robots.

This strange desert lizard is called a mali-uromastyx. He eats leaves, grass, and, sometimes, bugs.

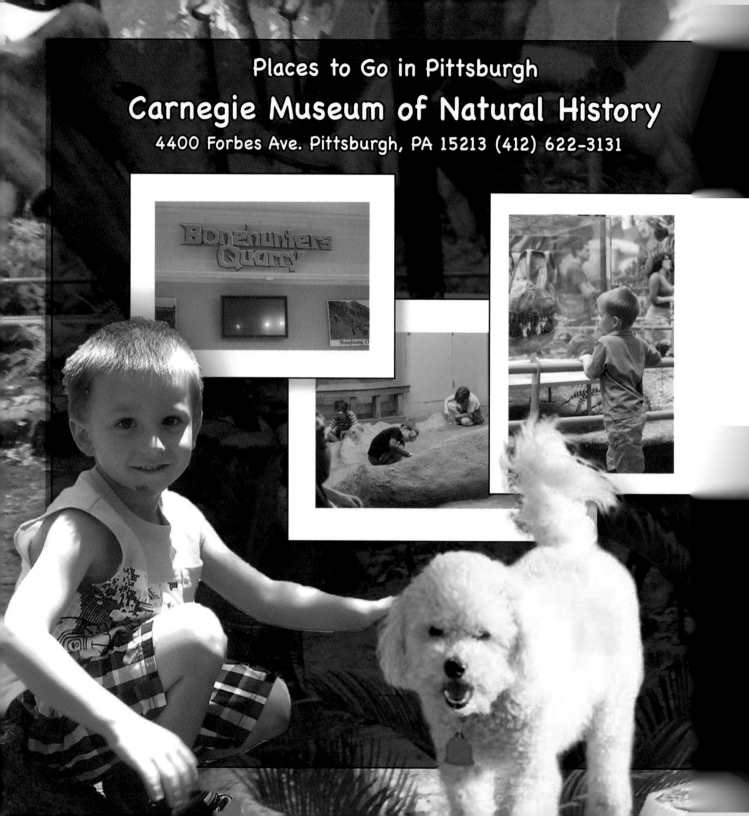

Places to Go in Pittsburgh

Carnegie Museum of Natural History

4400 Forbes Ave. Pittsburgh, PA 15213 (412) 622-3131

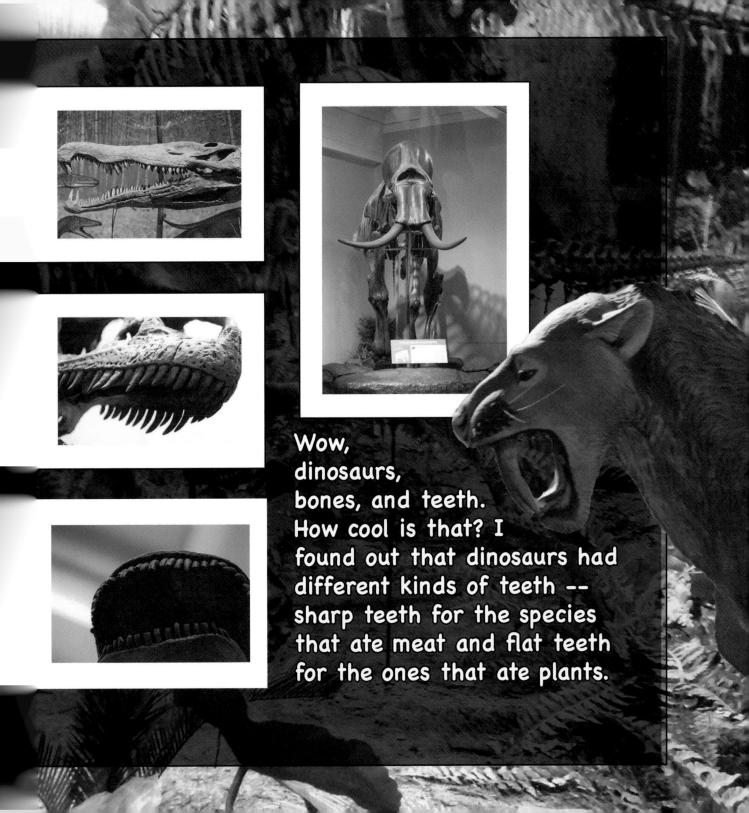

Wow,
dinosaurs,
bones, and teeth.
How cool is that? I
found out that dinosaurs had
different kinds of teeth --
sharp teeth for the species
that ate meat and flat teeth
for the ones that ate plants.

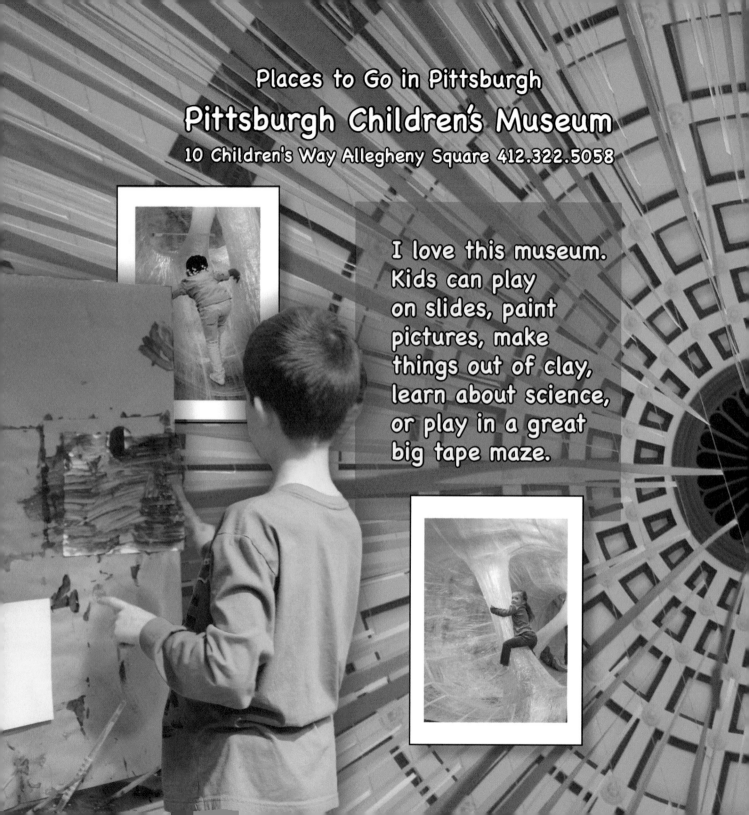

Places to Go in Pittsburgh

Pittsburgh Children's Museum

10 Children's Way Allegheny Square 412.322.5058

I love this museum. Kids can play on slides, paint pictures, make things out of clay, learn about science, or play in a great big tape maze.

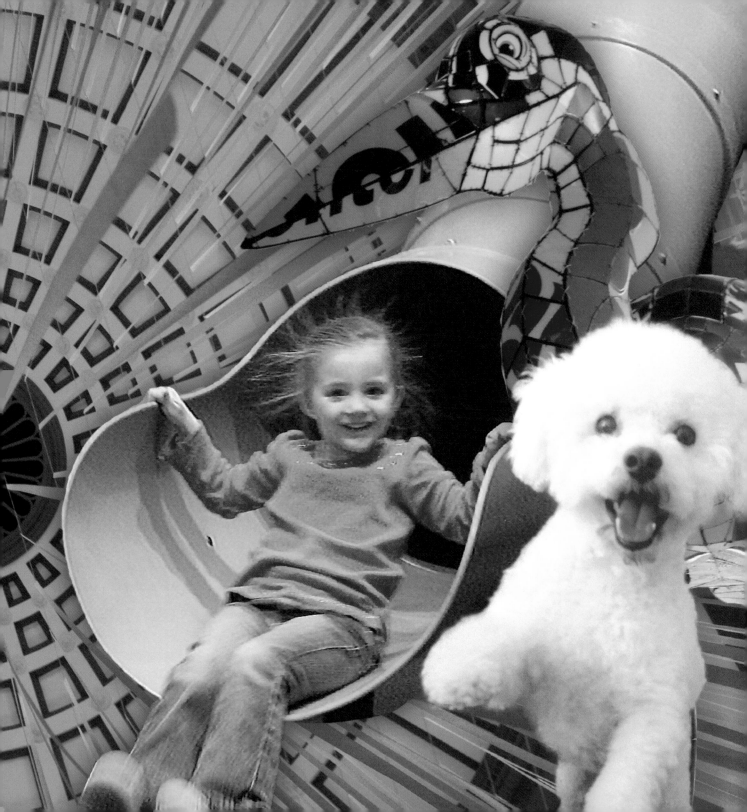

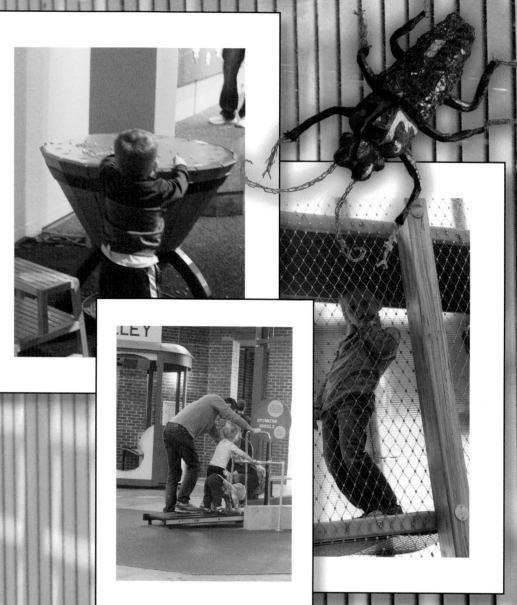

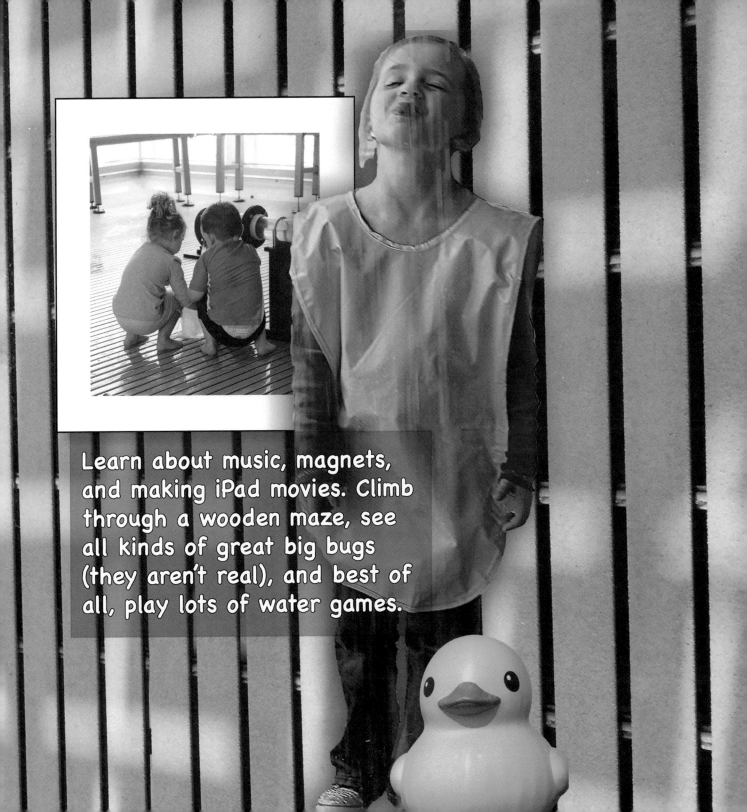

Learn about music, magnets, and making iPad movies. Climb through a wooden maze, see all kinds of great big bugs (they aren't real), and best of all, play lots of water games.

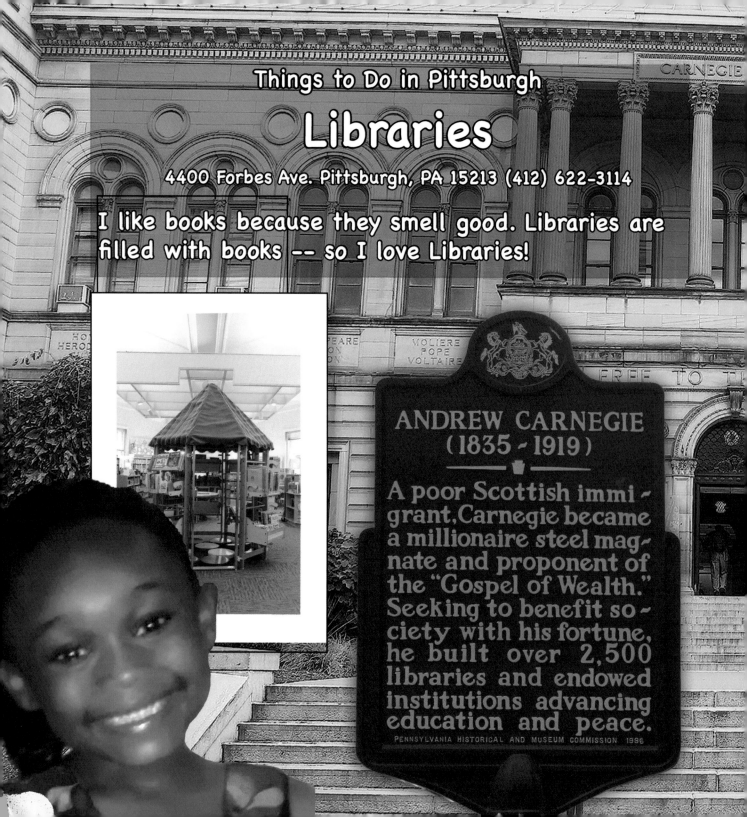

Things to Do in Pittsburgh

Libraries

4400 Forbes Ave. Pittsburgh, PA 15213 (412) 622-3114

I like books because they smell good. Libraries are filled with books -- so I love Libraries!

ANDREW CARNEGIE
(1835 ~ 1919)

A poor Scottish immi~
grant, Carnegie became
a millionaire steel mag~
nate and proponent of
the "Gospel of Wealth."
Seeking to benefit so~
ciety with his fortune,
he built over 2,500
libraries and endowed
institutions advancing
education and peace.

PENNSYLVANIA HISTORICAL AND MUSEUM COMMISSION 1996

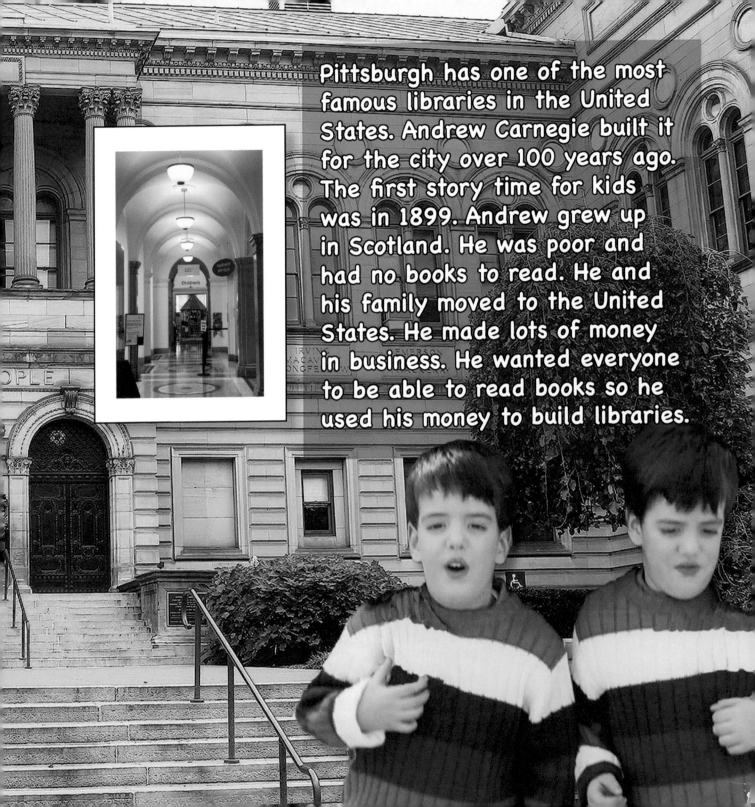

Pittsburgh has one of the most famous libraries in the United States. Andrew Carnegie built it for the city over 100 years ago. The first story time for kids was in 1899. Andrew grew up in Scotland. He was poor and had no books to read. He and his family moved to the United States. He made lots of money in business. He wanted everyone to be able to read books so he used his money to build libraries.

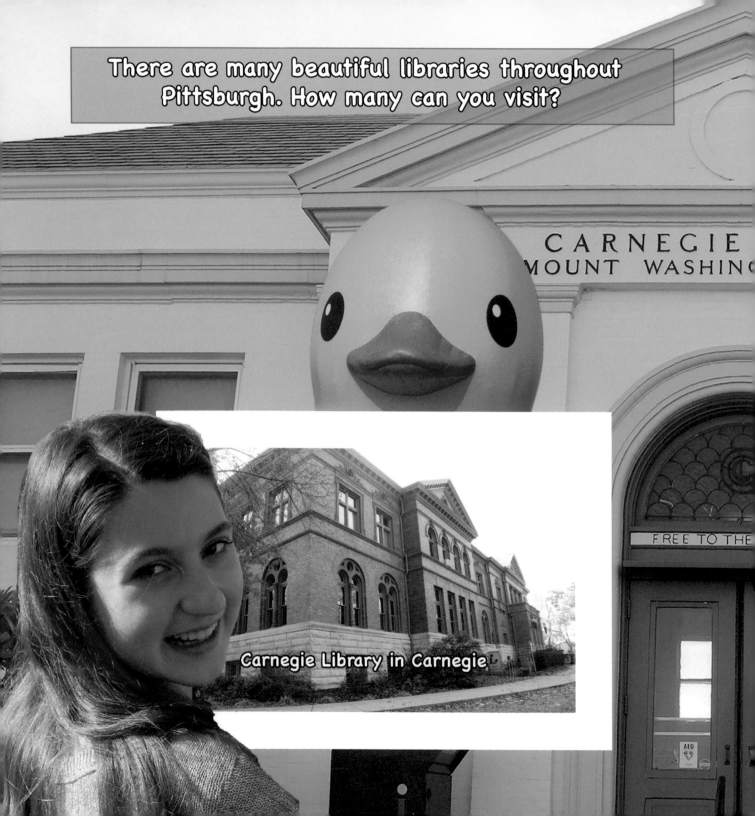

There are many beautiful libraries throughout Pittsburgh. How many can you visit?

CARNEGIE
MOUNT WASHINC

FREE TO THE

Carnegie Library in Carnegie

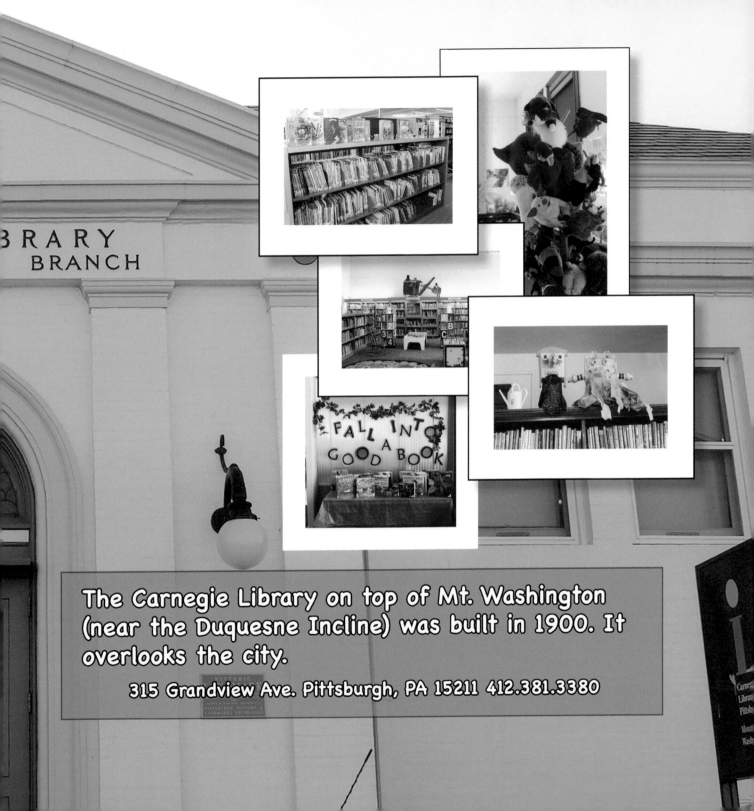

BRARY
BRANCH

The Carnegie Library on top of Mt. Washington
(near the Duquesne Incline) was built in 1900. It
overlooks the city.

315 Grandview Ave. Pittsburgh, PA 15211 412.381.3380

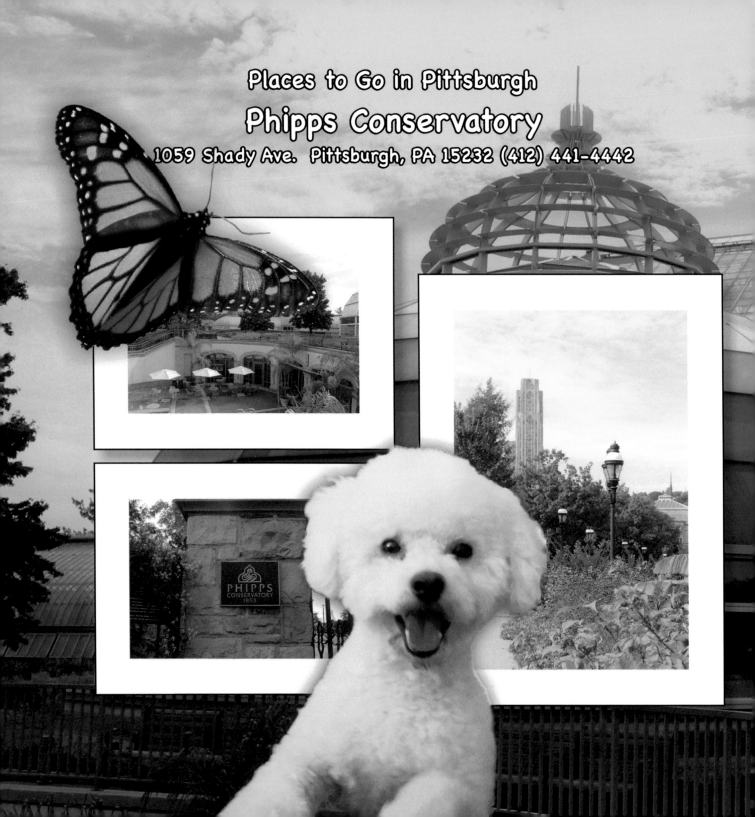

Places to Go in Pittsburgh

Phipps Conservatory

1059 Shady Ave. Pittsburgh, PA 15232 (412) 441-4442

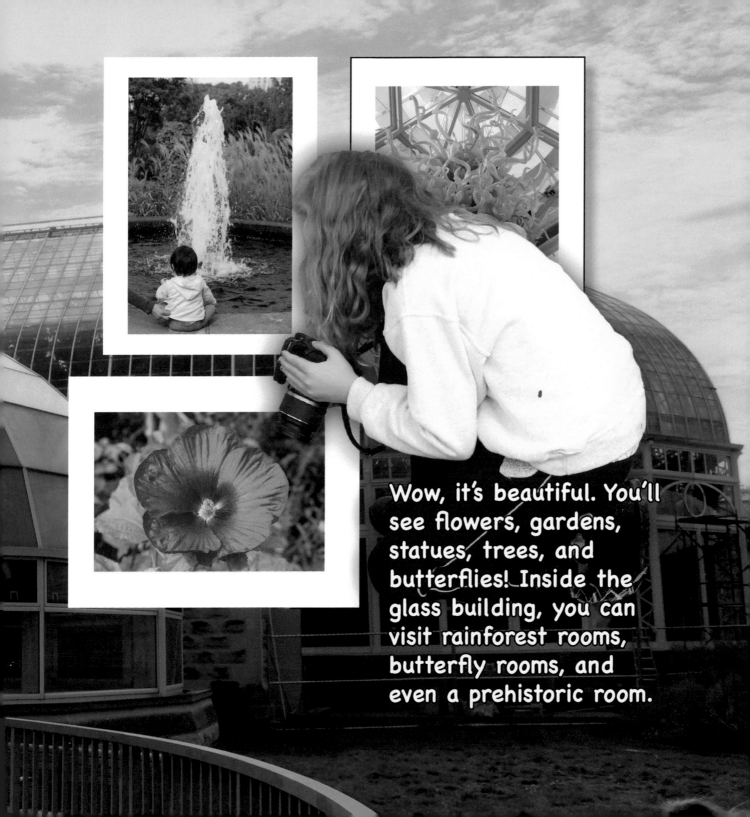

Wow, it's beautiful. You'll see flowers, gardens, statues, trees, and butterflies! Inside the glass building, you can visit rainforest rooms, butterfly rooms, and even a prehistoric room.

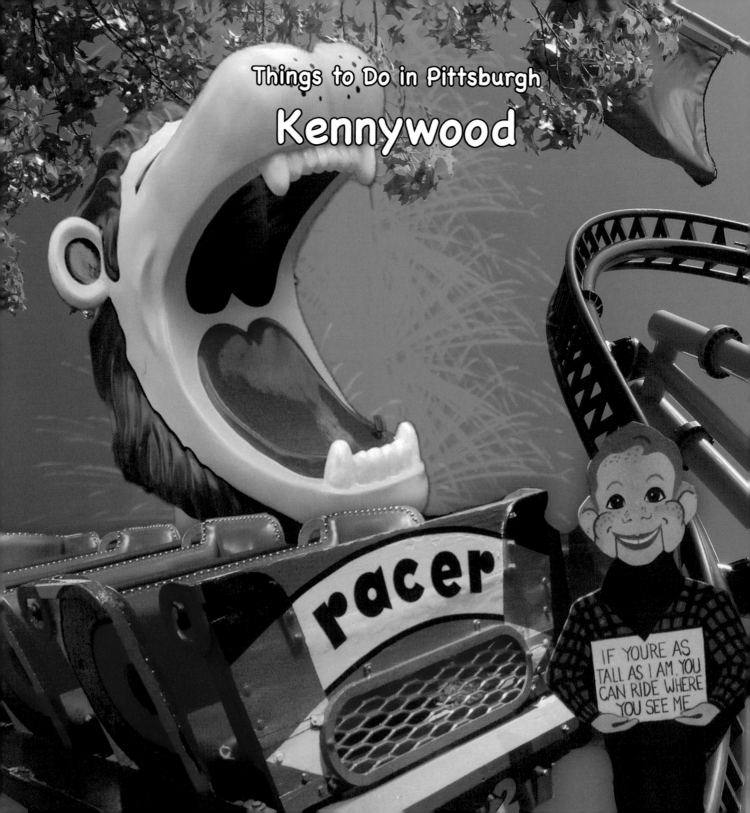

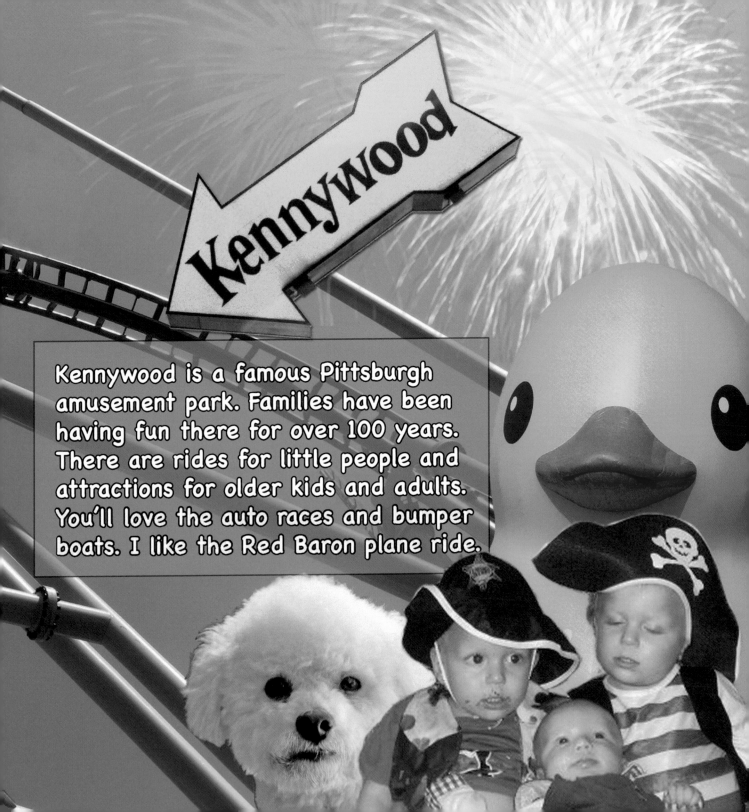

Kennywood is a famous Pittsburgh amusement park. Families have been having fun there for over 100 years. There are rides for little people and attractions for older kids and adults. You'll love the auto races and bumper boats. I like the Red Baron plane ride.

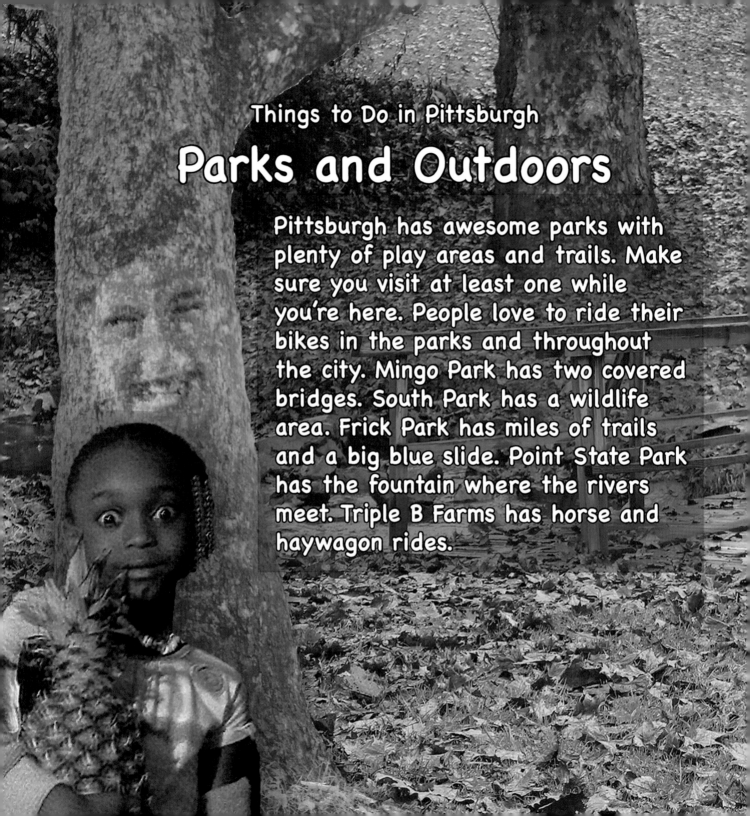

Parks and Outdoors

Pittsburgh has awesome parks with plenty of play areas and trails. Make sure you visit at least one while you're here. People love to ride their bikes in the parks and throughout the city. Mingo Park has two covered bridges. South Park has a wildlife area. Frick Park has miles of trails and a big blue slide. Point State Park has the fountain where the rivers meet. Triple B Farms has horse and haywagon rides.

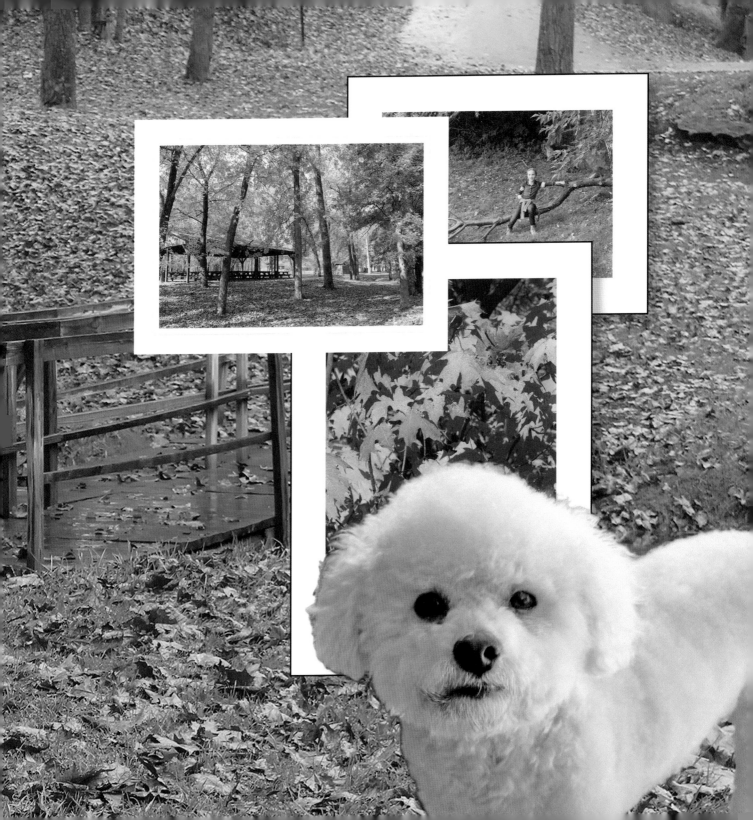

More Parks and Outdoors

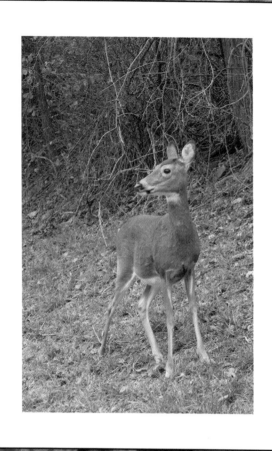

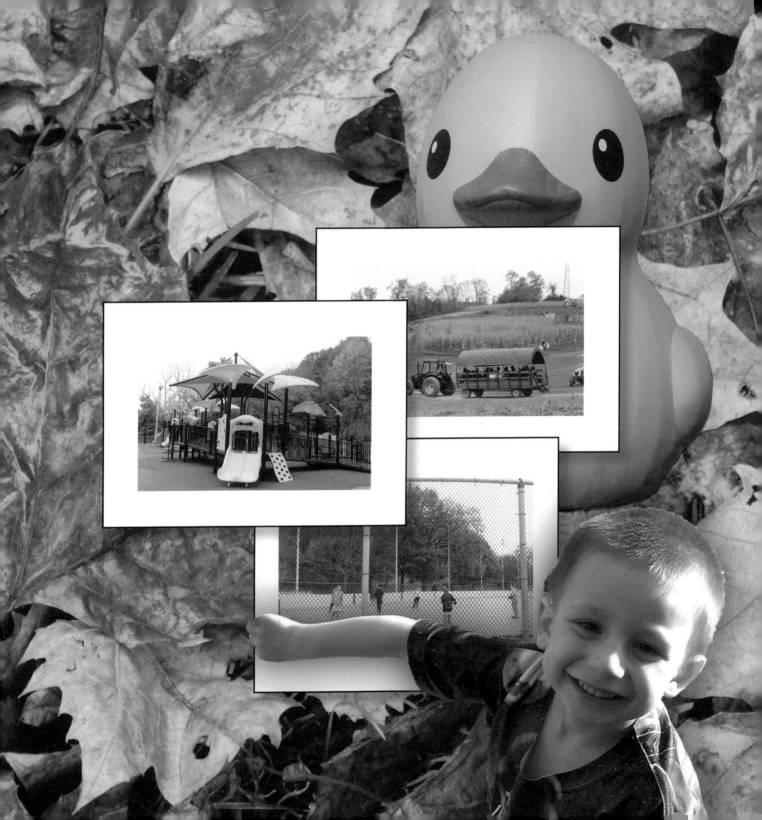

Pittsburgh Sports Word Search
Look for these words in the puzzle on the next page!

Biking, Hiking,
Racing, Skating, Running, Baseball,
Marathon, Basketball, Football, Pirates,
Passion, Penguins, Panthers, Steelers,
Tartans, Riverhounds

```
J B M W S L Q R P A S S I O N
R I K A A N P S K A T I N G R
I K E B R D A R A C I N G U R
V I R P A A O T T D N F S L U
E N Y B E S T A R Y W R V L N
R G A G T N K H S A E Q R A N
H F S Z G S G E O H T G F B I
O O Y M N O T U T N A B R E N
U O I P I G Z N I B A V D S G
N T C I K M A D H N A V B A T
D B B R I P U D H Z S L S B U
S A I A H R V A S X L S L R K
N L T T S B X H E V B T O O S
S L I E F V Q P A K X Y T N C
X H K S E S T E E L E R S J A
```

More Pittsburgh for Kids

The Pittsburgh Zoo
Pittsburgh Children's Theater
Just Ducky Tours
Troy Hill Spray Park
North Park Boat House

The Good Ship Lollipop
PPG Plaza Water Fountain
Schenley Park Ice Skating Rink
Cinema In the Park
Sandcastle Water Park
Idlewild
Fort Ligonier

I only visited a few of Pittsburgh's
many attractions. Check out some of
the others listed on this page.

In memory
of
Dante Spampinato
07/26/05 - 03/23/13

Many thanks to the children who participated in
this book,

Aaron, Anaiyah, Anthony, Blake, Daniel, Dante, Hannah,
Jacob, Jasper, Madison, Maggie, Nathan, Rebekah,
and Roman

and to their parents and grandparents.

CPSIA information can be obtained
at www.ICGtesting.com
Printed in the USA
LVIC04n1214160314
377582LV00001B/1

9 7 8 1 9 3 7 9 5 8 5 7 2